GUSTAV KLIMT

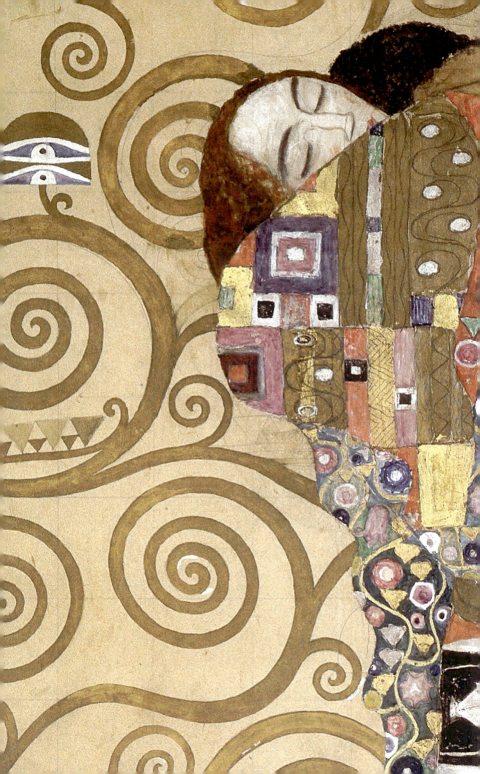

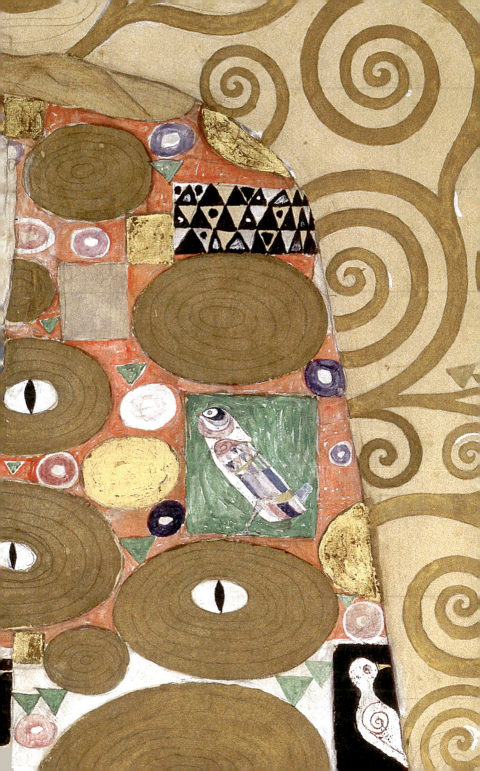

GUSTAV
KLIMT

Wilfried Rogasch

HIRMER

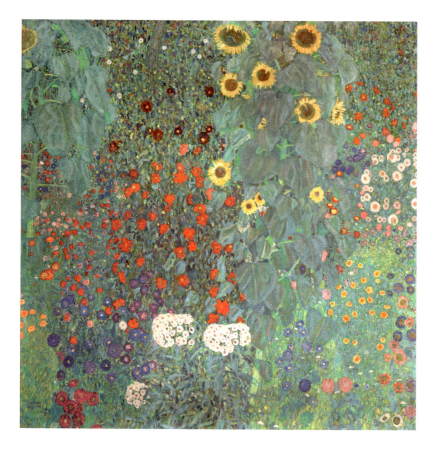

GUSTAV KLIMT

Farm Garden with Sunflowers, c. 1907
Oil on canvas, 110 × 110 cm, Belvedere, Vienna

CONTENTS

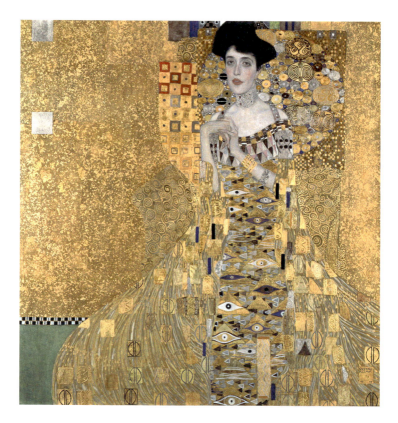

1 *Adele Bloch-Bauer I*, 1907, oil, silver and gold leaf on canvas
138 × 138 cm, Neue Galerie, New York

GUSTAV KLIMT – STAR OF VIENNA'S BELLE ÉPOQUE

Wilfried Rogasch

On 19 June 2006, the *New York Times* reported that the American billionaire Ronald S. Lauder (born 1944) had bought Gustav Klimt's portrait of *Adele Bloch-Bauer I* (1) for the record sum of 135 million dollars (106.7 million euros). At the time this was the highest price ever paid for a painting. The work was sold by Adele Bloch-Bauer's heir, her niece Maria Altmann (1916–2011).

The sale had been preceded by a spectacular and protracted legal battle between Maria Altmann and the Republic of Austria, in which it appeared for a long time that Frau Altmann had no chance of recovering the portrait and four other Klimt paintings stolen from the Jewish family by the National Socialists. In addition to the painting *Adele Bloch-Bauer I* (1907), nicknamed "Golden Adele," there was also a second portrait of her, *Adele Bloch-Bauer II*, from 1912 (2), and three landscapes.

The Austrian government referred to a passage in Adele Bloch-Bauer's will from 1923, according to which the paintings in her possession were to go to the Österreichische Galerie: "I request that on his death my husband leave my two portraits and four landscapes by Gustav Klimt to the Österreichische Staatsgalerie in Vienna." Adele's widower, the industrialist Ferdinand Bloch-Bauer (1864–1945), had doubtless planned to give the six

Klimt paintings to the Österreichische Galerie on his death, for in 1936 he had already given the gallery one of the four landscape paintings, *Schloss Kammer on the Attersee III* (28).

After Austria's "Anschluss" to the National Socialist German Reich in March 1938, Ferdinand Bloch-Bauer fled to Switzerland. He died in Zurich in November 1945, without having returned to Vienna. In his will he had previously revoked all intended gifts to Austrian museums. The Nazi regime had confiscated Bloch-Bauer's estate and sold his important art collection. The "Golden Adele" had been bought by the Österreichische Galerie in 1941. This is remarkable, for Klimt's style did not accord with the National Socialist notion of art and moreover the subject was Jewish.

In 1903 Ferdinand Bloch-Bauer had commissioned the artist to paint an imposing portrait of his wife. Klimt promptly produced some 100 drawings as preliminary studies (see pp. 75, 76) – more than for all his other paintings. He was not a swift painter; he worked on the picture for four years. The artist portrayed almost exclusively women on commission, and today it is his most famous portrait.

Maria Altmann described her aunt as follows: "Sickly, ailing, always with a headache, smoking like a chimney, frightfully delicate, gloomy. A spiritual face, narrow, elegant. Smug, arrogant, that's how she struck me as a child. Always in search of intellectual excitement." In the square painting the subject appears in the right half, while the left half of the picture is filled with flat ornaments in gold and silver leaf, producing a sumptuous, almost sacral effect. Klimt largely dispensed with any representation of space. The only realistically painted elements are the head, the décolleté, the hands, and the forearms in the upper right quarter of the picture. The slender figure wears a close-fitting gold dress and wide gold cape, pictured flat, that blend with the gold background. Except for the rouged cheeks, her complexion is strikingly pale, contrasting with the sensuous red mouth and upswept black hair. Her dress is completely covered with ornaments, including rectangles, triangles, and stylised eyes.

The portrait dates from Klimt's so-called "Golden Period." Around 1900 he increasingly added gold to his palette, in his *Pallas Athena* (3) and *Judith I* (15), for example. On a trip to Italy in 1903 he had seen the gold mosaics in Ravenna's churches, which left a strong impression on him. He subsequently produced numerous other works in which gold either predominates or at least provides special accents.

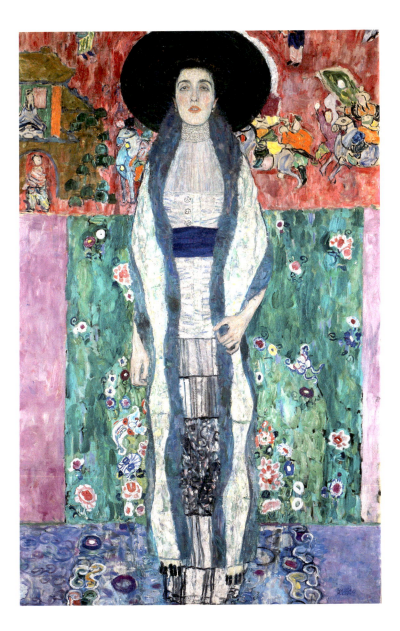

2 *Adele Bloch-Bauer II*, 1912, oil on canvas, 190 × 120, private collection

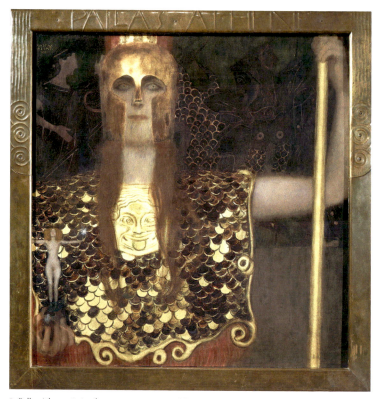

3 *Pallas Athena*, 1898, oil on canvas, 75 × 75 cm, Wien Museum

Whereas in the first decades after 1945 the provenance of artworks from confiscated Jewish collections was never mentioned in Austrian museums, in the 1990s the issue began to be reconsidered. In 1998 Parliament passed an art restitution bill that has since served as the guideline for dealing with stolen art from the Nazi period.

In 2006 the disputed pictures were restituted to Maria Altmann. During the court proceedings the *Portrait of Adele Bloch-Bauer*, a major work of Klimt's and of Vienna's Jugendstil, was referred to in the media as an "icon of Austria's national identity" and "the Viennese Mona Lisa," which should be kept in the country at any price. The estimated 250 million euros required to purchase the Bloch-Bauer works as important pieces of the

country's cultural heritage and keep them in Austria could not be raised. So the works were shipped to New York, where Maria Altmann sold the "Golden Adele" to Lauder, who put it on display it his Neue Galerie in Manhattan. The other four works were auctioned in that same year. The portrait *Adele Bloch-Bauer II* was purchased by the American talk show moderator Oprah Winfrey for 88 million dollars (68.8 million euros); the three landscape paintings went to anonymous bidders.

THE EARLY YEARS

The later 'painter-prince' Gustav Klimt, born in 1862, grew up in simple circumstances. His father Ernst Klimt had a wife and seven children to feed on his modest income from his work as a gold engraver. It is tempting to think that Klimt's later fondness for gold went back to childhood memories.

Gustav's extraordinary talent for drawing was noted early on. In 1876, provided with a stipend, he was admitted at the age of 14 to the school of applied arts attached to the Österreichisches Museum für Kunst und Industrie. As opposed to the Akademie der Bildenden Künste, which turned out academic painters and sculptors, students at the Kunstgewerbeschule were trained in seven years of schooling as craftspeople whose job would be to supply tasteful designs for industrial products like furniture, lamps, china, tableware, carpets and textiles. Although Klimt evolved into an autonomous artist, beyond the requirements of the school, and one who could hold his own with any of the painters trained at the Academy, he always kept applied arts in mind and pursued the *Gesamtkunstwerk*, as realised by the Wiener Werkstätte, founded in 1903, with which he worked closely for a time.

Modernism came to Vienna relatively late, later than in Paris, Munich or Brussels. Although Klimt would later become the most prominent representative of the new departure in art, his initial style was wholly in accordance with the Historicist tradition. He executed his first commissions together with his younger brother Ernst and Franz Matsch, a talented fellow-student. Among these were contracts for the architectural firm Fellner & Helmer, which over a period of 40 years built some 50 theatres in the crown lands of the Danube Monarchy and other European countries.

4 *The Antique Theatre in Taormina*, 1887, resin oil on plaster, approx. 750 × 400 cm
Ceiling painting in the north stairwell of Vienna's Burgtheater

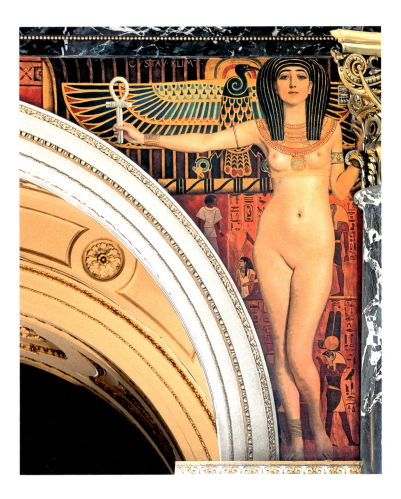

5 *Egyptian Art I*, 1890/01, oil on stucco, approx. 230 × 230 cm
Spandrel painting in the stairwell of the Kunsthistorisches Museum, Vienna

The three artists produced decorative paintings for a number of theatres, for example in Karlsbad in Bohemia and Fiume (Rijeka) in Croatia. In 1883 they founded the "Artists Company", a studio collective which operated for more than ten years. In its first years the painting styles of the three young artists were scarcely distinguishable. After successes in the provinces they also received commissions in Vienna itself. They were engaged to paint the ceilings in the monarch's bedroom and salon in the Hermes Villa, a gift from Emperor Franz Joseph to Empress Elisabeth.

On the grand Ringstrasse, whose imperial structures were largely completed in the 1880s, the "Company" was involved in the decoration of three public buildings. It produced the paintings for the two main stairwells in the new Hofburg-Theater. The Emperor was so pleased with Klimt's painting *The Antique Theatre in Taormina* (4), with its erotically accented depiction of a veil dancer, that in 1888 he awarded the artists the Gold Cross of Merit. They also executed the stairwell paintings in the Kunsthistorisches Museum, opened in 1891. Klimt was responsible for the 13 allegorical female figures representing epochs in art history from ancient Egypt to the Renaissance, which were unanimously praised by the critics (5).

THE FACULTY PAINTINGS
———

It was planned that the main hall of the new University of Vienna would be decorated with paintings of the four faculties Theology, Philosophy, Medicine and Jurisprudence. In 1894 the commission was awarded to Klimt and Matsch, who shared the job: Klimt would produce the representations of Philosophy, Medicine and Jurisprudence (6–8), while Matsch would picture Theology and execute the central ceiling painting *The Triumph of Light over Darkness*.

Klimt worked on the faculty paintings at a time when his style was changing radically. His designs for the works caused a scandal. His representation of Philosophy bore no resemblance to his earlier decorative painting. He made no attempt to glorify the discipline, as was expected. Instead, his design featured one of the leitmotifs of art around 1900: the life of man, integrated in the cycle of nature from birth to death.

His painting of Medicine also failed to agree with the professors' self-image. Nothing in it pictured medicine as the life-saving art of healing that

at the time was making notable advances; nowhere was there a celebration of scientific progress. A female nude, rendered at a steep angle from below, symbolised life, but Klimt's critics considered it offensive. The right-hand side of the picture featured a tangle of figures, from infants to old men. In their midst stood Death, against which Medicine is ultimately powerless, as a skeleton. In 1898 Klimt's paintings were sharply criticised by the university's art committee, both for their content and their form, while Matsch's pictures were found to be perfectly acceptable. Eighty-seven professors signed a protest, and the artist was asked to rework his paintings. After much back and forth, in 1907 he took back the three paintings and paid back his artist's fee. He would never again accept a public commission.

THE VIENNA SECESSION

In the spring of 1897 nineteen progressively-minded artists joined together to form the "Association of Visual Artists – Vienna Secession". In addition to Klimt, the group included Koloman Moser, Josef Hoffmann, Joseph Maria Olbrich, Max Kurzweil and Adolf Hölzel. The precedent for this split from the conservative "Association of Austrian Artists" was the Munich Secession, founded in 1892. Klimt served as the first president of the new association from 1897 to 1899.

Around 1900 the metropolis at the heart of the Danube Monarchy with its two million inhabitants saw the beginning of an extraordinarily creative period in art and culture. This "Belle Époque" was in large part supported by the liberal Jewish upper middle class. Twenty years before the demise of multinational Austria-Hungary, the city could boast a number of intellectual giants blazing new and innovative trails in the liberation and modernisation of the arts. Among them were the artists Gustav Klimt, Egon Schiele, Oskar Kokoschka and Koloman Moser, the architects Otto Wagner, Joseph Maria Olbrich and Adolf Loos, the composers Gustav Mahler, Arnold Schönberg and Alban Berg, the writers Karl Kraus, Robert Musil, Arthur Schnitzler and Hugo von Hofmannsthal, and of course the psychoanalyst Sigmund Freud.

In a time that has been exaggeratedly called an "experiment in apocalypse," the Secessionists declared art to be a substitute religion bringing improve-

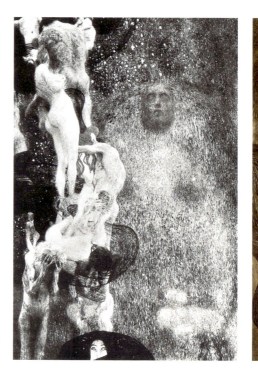

6 - 8 *Philosophy* (6),
Jurisprudence (7),
Medicine (8),
ceiling paintings
for the University of
Vienna auditorium,
1899–1907
Oil on canvas,
430 × 300 cm
destroyed by fire at
Schloss Immendorf
Lower Austria, 1945

ment to mankind and the world, one whose aesthetic would suppress all that was evil and ugly. But it soon became apparent that what these artists produced reached only a small, wealthy and elitist circle of buyers, and there could be no thought of a general betterment of the world through art.

In 1897/98 the association built the Vienna Secession Building on Karls-platz after plans by Joseph Maria Olbrich as an exhibition space (36). Above its portal stands the Secession's motto: "To Every Age Its Art – To Every Art Its Freedom." With its gilt cupola of stylised laurel leaves, the building is one of Vienna's most important Jugendstil structures to this day. Here, in rapid succession, works by the Secessionists were shown in two or three exhibitions a year. Klimt's paintings were frequently featured. The 14th exhibition in 1902 was wholly devoted to Ludwig van Beethoven, whose work, thanks to the efforts of Richard Wagner and Friedrich

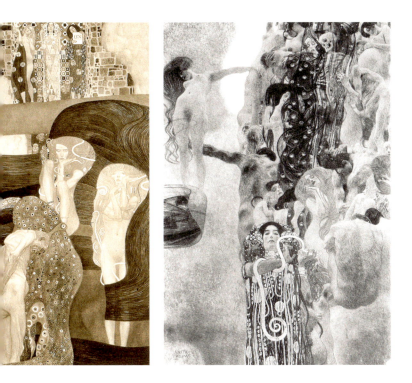

Nietzsche, was then enjoying a renaissance. In the centre of the shrine to the composer, designed as a *Gesamtkunstwerk* by Josef Hoffmann, stood the monumental sculpture of Beethoven by Max Klinger. The exhibition's most important work of art apart from the sculpture was Klimt's *Beethoven Frieze* (9, 10), some 34 metres long and two metres tall. The frieze is a high point in Klimt's œuvre, produced during his Symbolist phase, during which he frequently devoted himself to abstract assignments. Here, for example, Klimt found in Beethoven's compositions, especially in his *Ninth Symphony*, such subjects as "The Yearning for Happiness," "The Sufferings of Mankind," and "Joy, Lovely Spark of the Gods." Klimt pictured flat, monumental figures, the majority of them female, symbolising both good and evil forces. The figures are mostly presented in stylised rigidity, and arranged as an overall decorative ornament. The frieze culminates in a man and woman's embrace, symbolising the "Kiss for All the World." Here

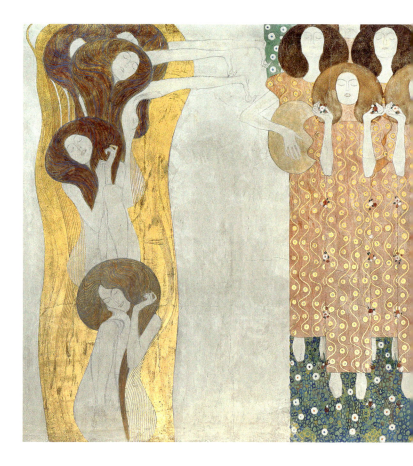

9 *Beethoven Frieze*, detail: *Joy, Lovely Spark of the Gods* and *This Kiss for All the World*, 1902
Casein pigment, gold leaf, semi-precious stones, mother-of-pearl, plaster, charcoal crayon,
pencil on stucco ground, 34.14 × 2.15 m, Belvedere, Vienna

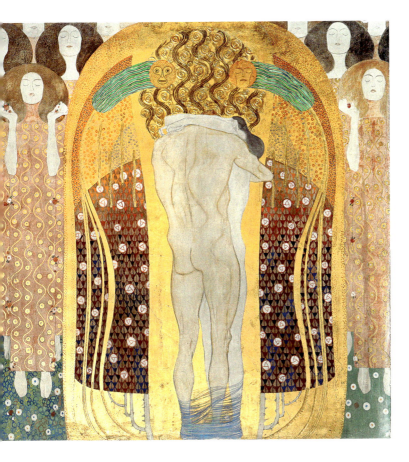

the woman is almost completely obscured by the figure of the nude man viewed from the back. Klimt again pictured the passionate embrace of a pair of lovers in the *Stoclet Frieze* in Brussels and most notably in his masterpiece *The Kiss* (11), which is now his most popular painting, reproduced by the millions. In this intimate scene the pair appear to be completely fused, yet at the same time masculinity is symbolised by the black rectangles and femininity by the bright flowers on their garments. Like so many of Klimt's paintings, the large-format picture *The Kiss* is a perfect square. Here the *femme fatale* that often dominates in Klimt's other pictures completely subordinates herself to the male. She is pictured kneeling, and

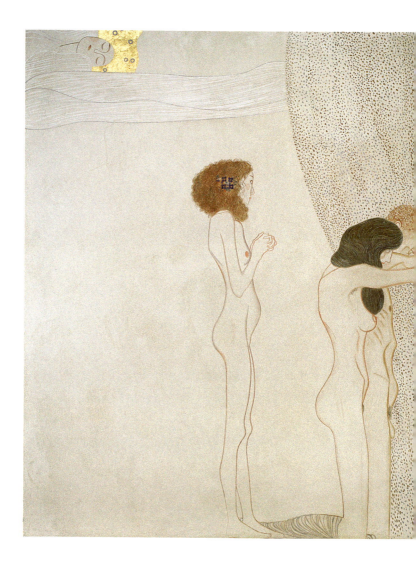

10 *Beethoven Frieze*, detail: *The Yearning for Happiness*, 1902
Casein pigment, gold leaf, semi-precious stones, mother-
of-pearl, plaster, charcoal crayon, pencil on stucco ground
34.14 × 2.15 m, Belvedere, Vienna

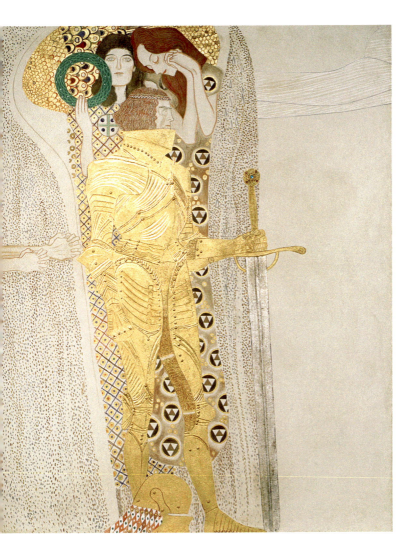

11 *The Kiss (The Lovers)*, 1908, oil on canvas
180 × 180 cm, Belvedere, Vienna

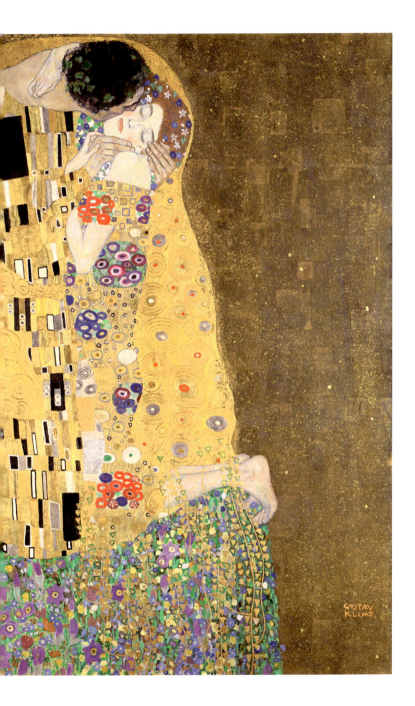

surrenders herself to him with closed eyes. The painting has been interpreted as everything from an allegory of love to a self-portrait of Klimt holding his lover Emilie Flöge in his arms.

THE STOCLET FRIEZE

In 1904 Klimt was commissioned by the Belgian couple Adolphe and Suzanne Stoclet to design the dining-room walls in their Brussels palais, as either a fresco, a mosaic, or a relief. Klimt chose a mosaic technique, and produced one of the major works from his "Golden Period." The Palais Stoclet was designed by Josef Hoffmann and furnished by the Wiener Werkstätte as a *Gesamtkunstwerk*.

The frieze, two metres tall, extends to a total length of 15 metres across the room's two long sides and end wall (43). On the west wall a spreading tree forms the centre of the work. Its golden branches, curled like volutes, cover the wall's entire surface. On the right we see a rose bush with butterflies fluttering about it, and on the left a young woman, richly ornamented with gold jewellery, whom Klimt referred to as the *Dancer*, the *Chinese Woman*, or *Anticipation* (12). Klimt gave the entire end wall of the room over to ornament. On the east wall the design of the west wall is repeated in mirror image, except that the dancer has been replaced by a pair of lovers, also called *Fulfilment* or *Embrace* (13). It is possible that his patrons were hoping for a kissing scene like the one already mentioned, which Klimt had painted in 1908 and which had been bought by the Österreichische Galerie for the high price of 25,000 kronen. The tiles of the frieze were made of slabs of marble inlaid with mosaic tesserae, glass, ceramic, metal, enamel and pearls and semi-precious stones in the dancer's jewellery. They were crafted in Vienna after Klimt's design drawings and shipped to Brussels, where they were set in place in the presence of the artist in 1911.

The depiction of the feminine in all its forms stands at the centre of Klimt's œuvre. The majority of his total output of 250 paintings are representations of women, and in addition there are several thousand nude drawings in which even especially intimate and explicit features are captured. In contrast to the elegant portraits of Viennese society women there are female nudes in which Klimt exceeded any previous depiction of female eroticism. In 1900 Vienna, sexuality as a driving force in humans was avidly discussed, not only in the writings of Sigmund Freud.

In 1899 Klimt painted *Nuda Veritas* (14), the 'Naked Truth', as a seductive, red-headed femme fatale in a provocative frontal view. The male fantasy of the sensuous, lascivious and at the same time dangerous, man-killing woman is the subject of the painting *Judith I* (15), for which Adele Bloch-Bauer probably served as the model. The beautiful biblical heroine Judith entered the camp of the enemy Assyrians, where she was presented to the commander Holofernes. She made him drunk and beheaded him with his own sword. Robbed of their leader, the Assyrians fled, and the people of Israel were saved.

Judith's half-closed eyes, her sensual, slightly open mouth, her bared breast, and her visible navel stand in contrast to the severed head of Holofernes, which is only partly visible. The gold background lends the painting an icon-like aura. Klimt pictured the subject of Judith a second time in 1909 (16), and here, too, the heroine has the features of Adele Bloch-Bauer.

Klimt was one of the first artists to picture pregnant nudes. The painting *Hope I* (17) shows a highly pregnant red-haired woman gazing at the viewer. In the background we can see a skull and grotesque masks, with which the painter describes the cycle from birth to death. It is possible that here Klimt was coming to terms with the death of his son Otto by his long-time lover Marie Zimmermann; the child died in 1902 when only a few months old.

Following double page:
12 (left) *Anticipation*, design for the Stoclet Frieze, 1905/09, mixed media on paper
193.5 × 115 cm, MAK – Museum für angewandte Kunst, Vienna
13 (right) *Fulfilment*, design for the Stoclet Frieze, 1905/09, mixed media with gold leaf on paper
194 × 121 cm, MAK – Museum für angewandte Kunst, Vienna

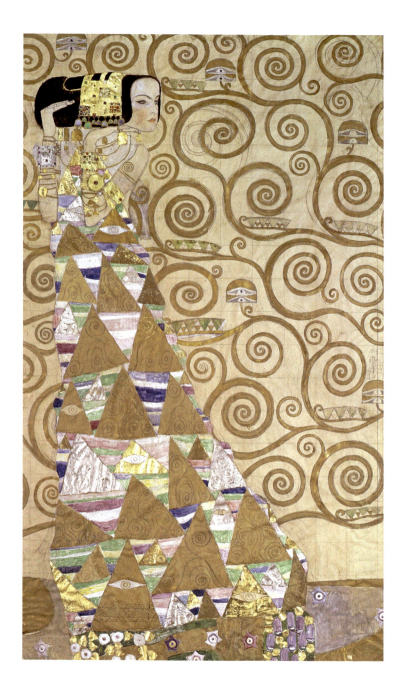

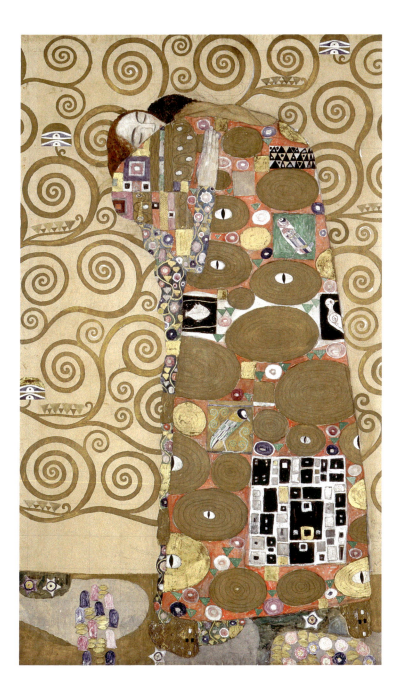

In 1908, at the same time as *The Kiss*, Klimt painted his *Danaë* (18), in which he celebrates female desire as in none of his other pictures. Danaë had been locked in a tower by her father, the king of Argos, so that no man could possess her. Thereupon Zeus approached her disguised as a shower of gold. The painting presents the moment of their union, in which the shower of gold enters her. Her huge thigh, her long red hair, and her closed eyes and open mouth serve to intensify the scene's eroticism.

FEMALE PORTRAITS

In 1888 Klimt was commissioned to paint a picture of the auditorium of the old Burgtheater with depictions of notable members of Viennese Society (19). The work was such a success that he became known henceforth as a portraitist of beautiful Viennese women. He himself emphasised that he had no wish to memorialize himself – there is only a single, unimportant self-portrait – and that he had little interest in portraits of men. But he painted at least 26 large-format portraits of society women on commission, and in addition countless portraits of lower-class women who modelled for him in his studio. One of his first portraits, from 1898, was of *Sonja Knips* (20), the daughter of a high-ranking officer and wife of the industrialist Anton Knips. The painting has the square format Klimt frequently chose, and is the only one of his portraits integrated into an impressionistic garden landscape.

A short time later, in 1902, Klimt painted his life partner and muse *Emilie Flöge* (21). She was not at all pleased with the painting, feeling that it failed to capture her essence, and the painter himself was not satisfied with it either. He therefore sold it to the Historisches Museum der Stadt Wien in Vienna. Emilie, who with her sisters Helene and Pauline operated a highly successful fashion salon in Mariahilfer Strasse in the Austrian capital, was a remarkable woman: trained as a dressmaker, she very soon became a fashion designer with her own collection. As many as 80 seamstresses worked for her. Twice a year she went to Paris to catch up on the latest trends in haute couture. She designed so-called "Reform" dresses that dispensed with corsets, as promoted by the women's movement to liberate the female body. Klimt also designed a series of "Reform" dresses with his typical ornaments.

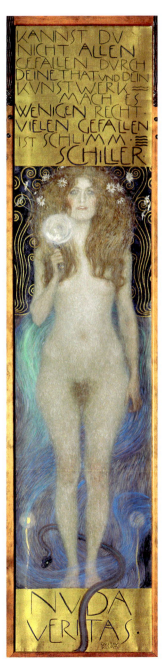

14 *Nuda Veritas*, 1899, oil on canvas
252 × 56 cm, Theatermuseum, Vienna

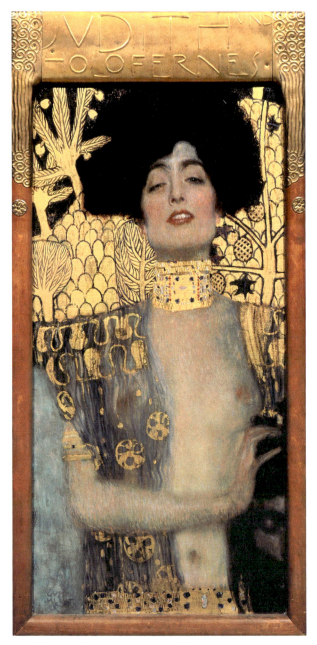

15 *Judith I*, 1901, oil on canvas, 84 × 42 cm, Belvedere Vienna

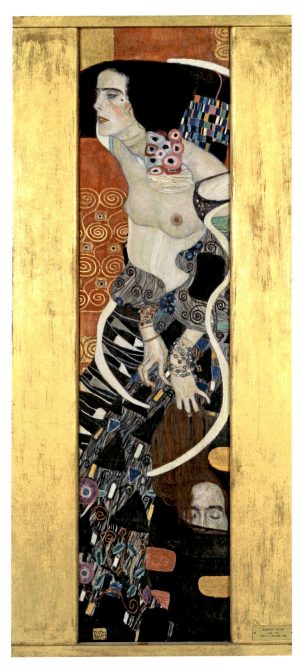

16 *Judith II*, 1909
Oil on canvas,
178 × 41 cm
Galleria Inter-
nationale d'Arte
Moderna in the
Palazzo Pesaro,
Venice

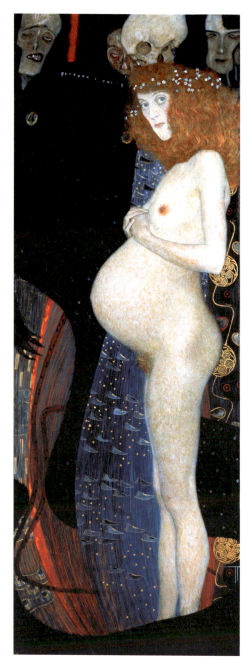

17 *Hope I*, 1903, oil on canvas
189 × 67 cm, National Gallery
of Canada, Ottawa

Klimt's relationship with Emilie was intense at the start, but he subsequently turned to various other women, with whom he fathered at least seven children. He was rumoured to have had affairs with many of his models. He never married, and lived with his mother and two unmarried sisters. He remained close to Emilie Flöge all his life, however, and for years they spent summers together on the Attersee, where Klimt devoted himself to landscape painting. In his last days, after a stroke, he called for Emilie, who watched at his sickbed to the end.

Serena Lederer, née Pulitzer, came from a wealthy Jewish family in Budapest, and was married to the Jewish industrial magnate August Lederer. In 1899 Klimt portrayed her as a youthful beauty in a white dress (22). Like almost all the women Klimt painted, she is pictured with red cheeks, which gives these portraits an erotic note. The painter gave Serena drawing lessons, and frequented her home as a friend of the family. The Lederers amassed the largest private collection of his works. In 1917 Klimt portrayed Serena's mother Charlotte Pulitzer, and between 1914 and 1916 her daughter Elisabeth. After the "Anschluss" of Austria in 1938, Elisabeth was recognised officially as an illegitimate child of Klimt's, which made her "half Aryan," so that she escaped deportation to an extermination camp. Her portrait, unquestionably one of his finest works, has East Asian riders, priests and elegant women in the background. Like Claude Monet and Vincent van Gogh, Klimt was fascinated by the flatness of Japanese and Chinese art, and found it similar in concept to his own work. East Asian figures appear in some of his later female portraits – *Adele Bloch-Bauer II* (1912) (2), for example, and *Friederike Maria Beer* (23).

Klimt's portrait of the 19-year-old *Gertrud Loew* (24) in a white dress with violet stripes is a miracle of delicacy. She was the daughter of a famous Jewish physician. In 1939 Gertrud Loew fled National Socialist persecution to the United States. Under unexplained circumstances, her portrait came into the possession of Gustav Ucicky, one of Klimt's sons. In 2015 his heirs reached an agreement with the descendants of Gertrud Loew to auction the painting and divide the proceeds. The picture was bought by the British billionaire Joe Lewis for 39 million U.S. dollars (34.8 million euros). Other major works from these years are the portraits of the 23-year-old *Margarethe Stonborough-Wittgenstein* (25) and the 46-year-old *Fritza Riedler* (26). Both women are pictured in white dresses against flat backgrounds, and in both paintings gold leaf provides special accents.

18 *Danaë*, 1908, oil on canvas
77 × 83 cm, private collection

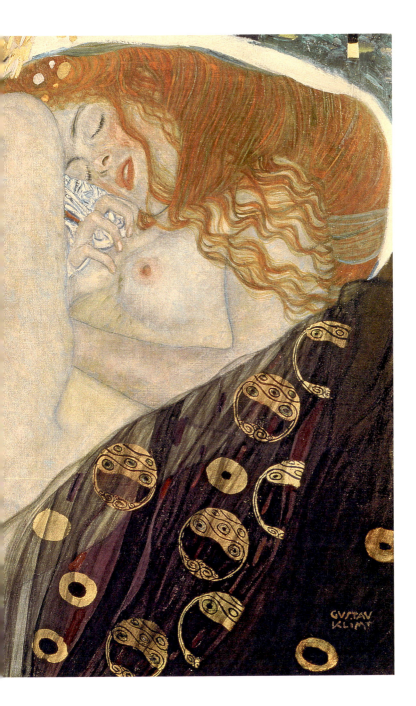

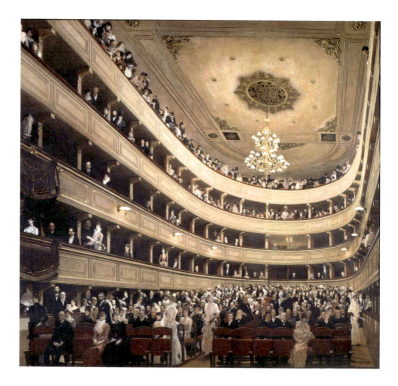

19 *The Auditorium of the Old Burgtheater*, 1888, watercolour and gouache on paper, gold highlights, 82 × 92 cm, Wien Museum

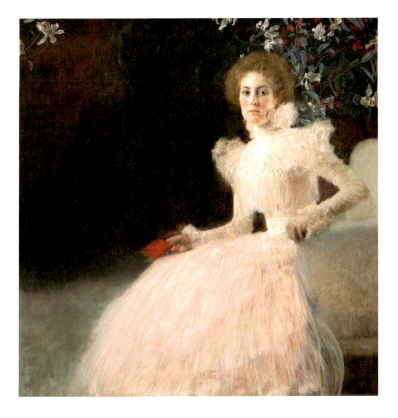

20 *Sonja Knips*, 1898, oil on canvas, 145 × 146 cm, Belvedere, Vienna

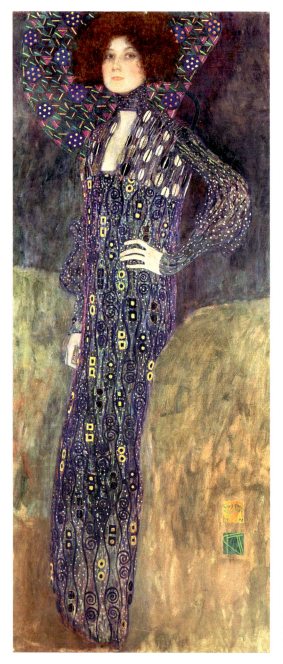

21 *Emilie Flöge*, 1902
Oil on canvas
181 × 84 cm
Wien Museum

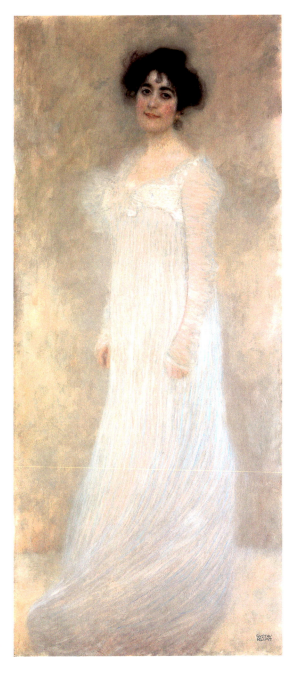

22 *Serena Lederer,*
1899, oil on canvas
188 × 83 cm
The Metropolitan
Museum of Art
New York

Margarethe was the multi-talented daughter of the Jewish steel magnate Karl Wittgenstein and the sister of the philosopher Ludwig and the pianist Paul Wittgenstein. In 1905 she married the New York manufacturer Jerome Stonborough, also from a Jewish family, from whom she separated in 1923. She fled to the United States in 1940, but returned to Austria after the end of the Second World War. She managed to recover her property confiscated by the Nazi regime, including Klimt's portrait of her, which has hung in Munich's Neue Pinakothek since 1963, when it was sold by the family.

Friederike Riedler, called Fritza, wife of the engineer Alois Riedler, was one of the non-Jewish models Klimt painted. In her portrait Klimt perfected his geometric picture composition. This is true of the background as well as of the subject herself, who is rendered as a triangular structure. The armchair in which Fritza seated is ornamented with eyes of the Egyptian god Horus, similar to those on the dress of the "Golden Adele." Fritza's heirs sold the painting to the Österreichische Galerie in 1937.

Among Klimt's patrons were the Primavesis. The banker and industrialist Otto Primavesi rescued the Wiener Werkstätte from bankruptcy in 1914. In 1912 Klimt painted the couple's 9-year-old daughter, *Mäda Gertrude* (27). For this exquisite portrait Klimt chose a frontal view. The girl poses with self-assurance, almost as an adult, her legs apart and with her arms behind her back, gazing fixedly at the viewer. Mäda is wearing a white dress with a colourful wreath of flowers across her breast and a blue ribbon in her hair. The upper half of the flat background is violet; one could think of it as a back wall. The lower half is strewn with patches of colour, with shades of red, green, blue, and white suggestive of flowers, similar to those that adorn the girl's dress.

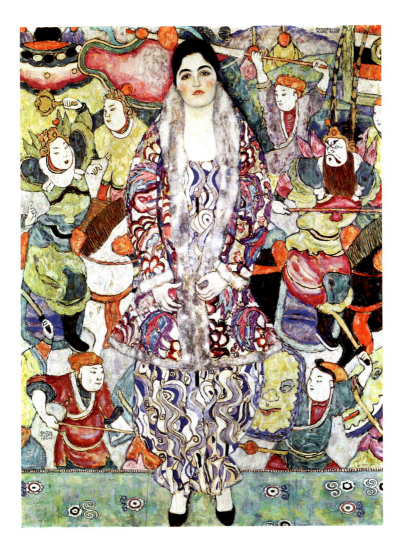

23 *Friederike Maria Beer*, 1916, oil on canvas, 168 × 130 cm
Mizne-Blumenthal Collection, Tel Aviv, Art Museum

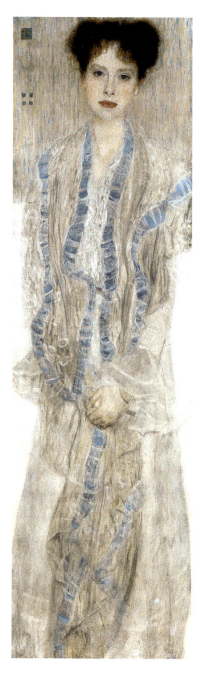

24 *Gertrud Loew*, 1902, oil on canvas
50 × 45.5 cm, private collection

25 *Margarethe Stonborough-Wittgenstein*, 1905
Oil on canvas, 179.8 × 90.5 cm
Bayerische Staatsgemäldesammlungen
Neue Pinakothek, Munich

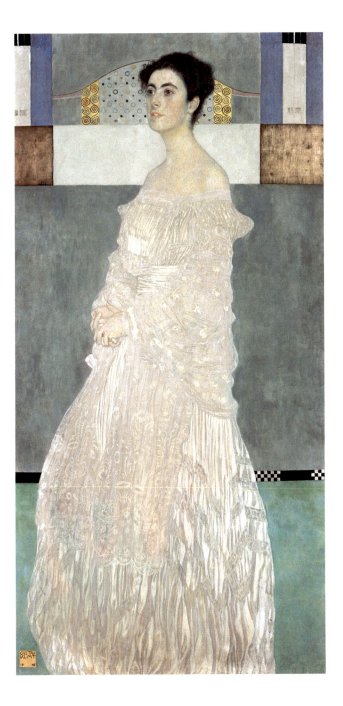

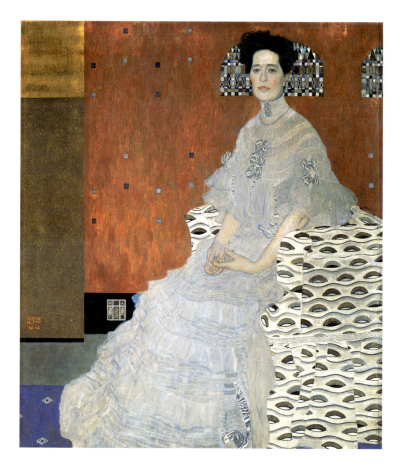

26 *Fritza Riedler*, 1906, oil on canvas, 153 × 133 cm
Belvedere, Vienna

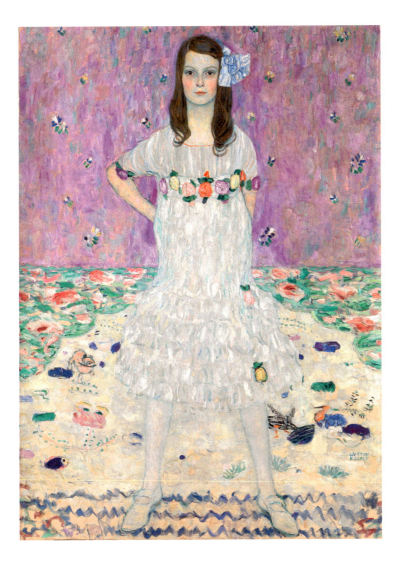

27 *Mäda Primavesi*, 1912, oil on canvas, 150 × 110 cm
The Metropolitan Museum of Art, New York

LANDSCAPE PAINTING

Klimt's landscape pictures represent a separate complex within his work. Aside from two or three early works produced around 1881, the artist did not start painting landscapes until he was 36. The landscape genre had not been called for in his work as a painter of decorations in theatres and museums. Another reason may have been that it was not until 1897 that he began spending his summers in the country, away from Vienna. Together with Emilie Flöge, he spent his vacation nearly every year between 1897 and 1916 in some summer resort, frequently on the Attersee in the Salzkammergut (28). And it was there that he painted most of his landscape pictures. He appears to have limited his landscape painting to the summer months, for the paintings exhibit exclusively an atmosphere of summer and early autumn. Colourful peasant gardens, heavily laden fruit trees, blooming meadows, and imposing avenues characterise his floral work (30). As in his portraits, spatial depth is rendered increasingly flat, with objects as ornaments. The works from around 1910 clearly indicate his study of the work of Vincent van Gogh, for example the painting *Avenue Leading to Schloss Kammer* (29)

Although the landscapes account for nearly a quarter of his œuvre, only a very few drawings of landscape motifs are found in his sketchbooks. Klimt painted directly onto the canvas from nature. From 1900 on he used exclusively square formats. In order to fix the section of the landscape for his picture, he made use of a view finder, a piece of cardboard into which he had cut out a square. Whereas his earliest pictures were still committed to a somewhat melancholy realism, his floral pictures became increasingly flat, virtually painted mosaics composed of countless bright dots of colour.

THE LAST YEARS

Klimt continued to paint women's portraits on commission even during the First World War. He suffered from the fact that his painting style was criticised by Expressionist artists from the younger generation like Egon Schiele and Oskar Kokoschka. He had initially promoted these painters by providing them with opportunities for exhibiting their pictures. And Schiele's early paintings owed much to those of Klimt.

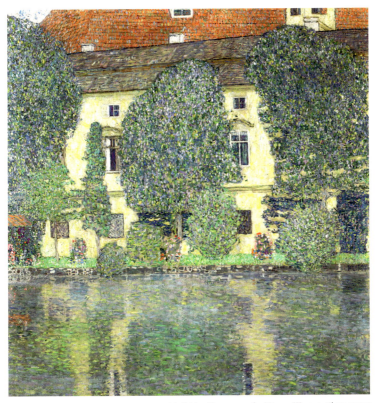

28 Schloss Kammer on the Attersee III, 1910, oil on canvas
110 × 110 cm, Belvedere, Vienna

In 1917 Klimt was named an honorary member of the art academies in
Vienna and Munich. His work was finally officially recognised. After his
death there were still countless unfinished canvases in his atelier. On
7 February 1912, the Viennese papers carried notices of the artist's death.
The *Arbeiter-Zeitung* reported: "Only 56 years old [sic], the famous, per-
haps one might even say the most famous, Viennese painter, Gustav Klimt,
succumbed yesterday to a stroke." And the Association of Austrian Artists'
obituary read: "Art has lost tremendously, humanity even more."
To this day Gustav Klimt is associated perhaps more than any other artist
with the Viennese Belle Époque. As a much-sought-after fresco painter
and progressively-minded founding president of the Vienna Secession, as

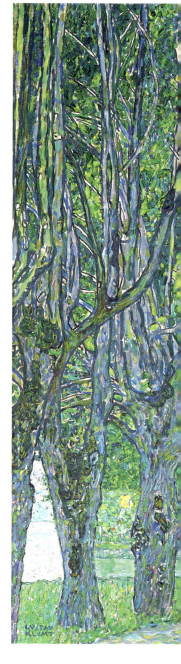

29 *Avenue Leading to Schloss Kammer*, 1912
Oil on canvas, 110 × 110 cm, Belvedere, Vienna

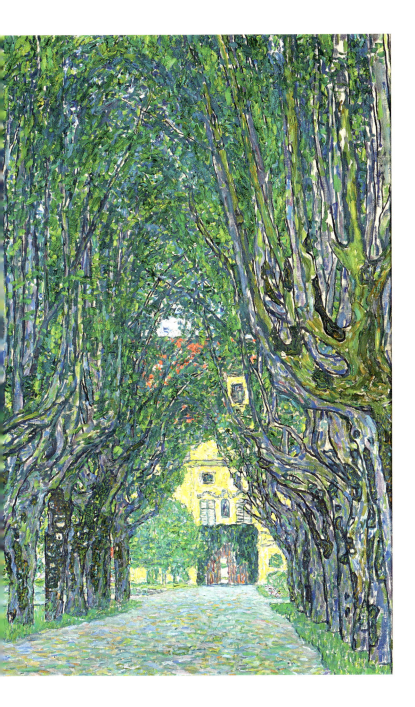

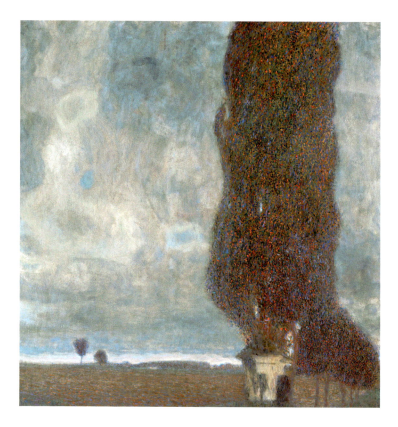

30 *Large Poplar (Rising Storm)*, 1902, oil on canvas
100.8 × 100.7 cm, Leopold Museum, Vienna

the undisputed favourite portraitist of upper-middle-class women, and as a draughtsman of forthright female eroticism, Klimt was both the *enfant terrible* and the darling of Viennese society. With works like *The Kiss* and the portraits of Adele Bloch-Bauer he created icons of art history that have been reproduced by the thousands – on postcards, posters, coffee mugs and umbrellas. For a genuine Klimt, those who can afford it have to pay untold millions of dollars at auction – Klimt has numbered among the world's most expensive painters for decades.

At the heart of Klimt's œuvre are depictions of the feminine in all its facets. He created a new image of woman that captured the Zeitgeist and with Viennese Jugendstil marked a departure into modernism. His early work still followed in the tradition of Historicism, but around the turn of the century he developed his "Golden Style," in which he painted his models in precious, highly ornamented garments blending with the decorative background. His works, filled with sensuality, eroticism and ecstasy, made him an outstanding star in early-twentieth-century Vienna, one of the most fascinating periods in the history of European art and culture.

WILFRIED ROGASCH *studied history and art history in Göttingen, Munich and Oxford. Since 1989 he has lived in Berlin as a freelance exhibition curator and writer. Among his numerous publications are* Bavaria in 24 Chapters, The 100 Most Beautiful Churches in Upper Bavaria, *and* Alfons Mucha, *volume 33 in the series "Junge Kunst".*

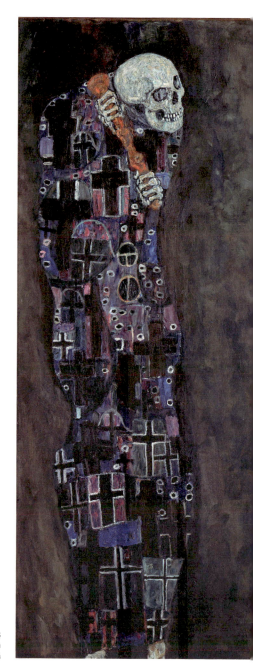

31 *Death and Life*, 1910/15
Oil on canvas, 178 × 198 cm
Leopold Museum, Vienna

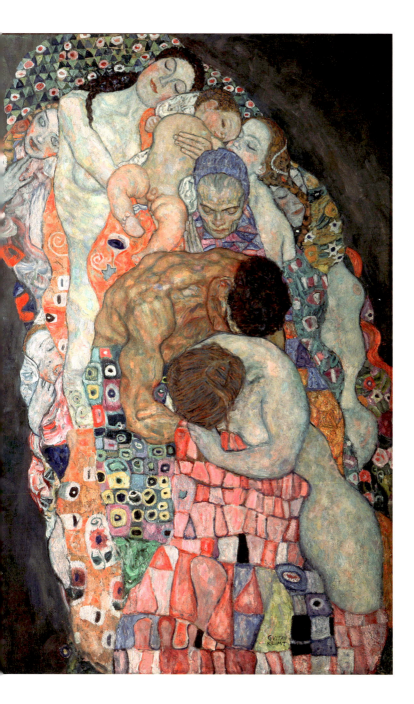

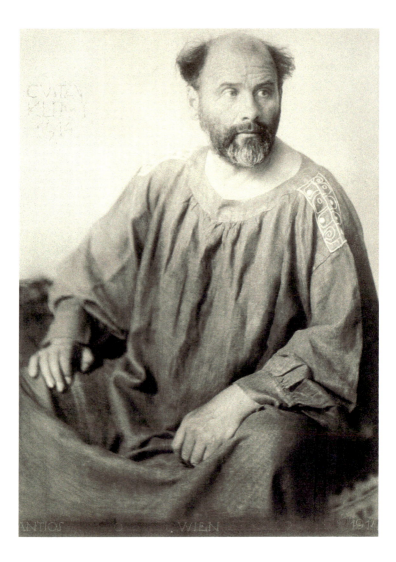

32 Gustav Klimt, 1914

BIOGRAPHY

Gustav Klimt
1862–1918

1862 Gustav Klimt is born on 14 July in Baumgarten bei Wien (now part of Vienna's 14th District). He is the second of seven children of the gold engraver Ernst Klimt (1834–1892) from Bohemia, and his wife Anna Rosalia, née Finster (1836–1915). The house will be torn down in 1966. With interruptions, he will live with his mother up to her death, as well as two of his unmarried sisters, Klara (1860–1937) and Hermine (1865–1937).

1867–1875 Klimt finishes primary and secondary schools. The family moves repeatedly: first to Lerchenfelder Strasse 50 in the 8th District, then to Neubaugasse 51 in the 7th District, to Märzstrasse 48 in the 15th District, and finally in 1875 to Märzstrasse 40.

1876 Furnished with a scholarship, Klimt attends the School of Applied Art (now the University of Applied Arts Vienna) run by the Österreichisches Museum für Kunst und Industrie, until 1883. His academic teachers include the painters Ferdinand Laufberger, Victor Berger, Ludwig Minnigerode and Michael Rieser, and the graphic artist Karl Hrachowina. His brothers Ernst (1864–1892) and Georg (1867–1931) soon become his fellow students. He works intensively with Ernst; the two brothers draw portraits together after photographs, which they sell for 6 guilders apiece. Another fellow student is Franz Matsch (1861–1942), with whom Gustav and Ernst become friends and enter into a close working association.

1879 Gustav Klimt works on the historic pageant in celebration of the silver wedding anniversary of Emperor Franz Joseph I and Empress Elisabeth, staged under the direction of Hans Makart (1840–1884).

1883 Together with Ernst Klimt and Franz Matsch, Gustav forms the "Artists Company," an association in which the three artists will collaborate up into the 1890s. The three set up an atelier at Sandwirtgasse 8 in the 6th District. They receive regular commissions, for example for the interior painting of theatres in Fiume (now Rijeka, Croatia), Karlsbad (now Karlovy Vary, Czech Republic), Reichenberg (now Liberec, Czech Republic), and Bucharest, as well as in the Romanian royal palace Peleş, in the Carpathians, and the Palais Sturany on Vienna's Ringstrasse.

33 The house where Gustav Klimt was born in the present-day 14th District in Vienna Linzer Strasse 247, 1918

34 Gustav Klimt (centre) between Hermann August Flöge (left), the father-in-law of his brother Ernst Klimt, and an unidentified man in the garden of his atelier at Josefstädter Strasse in Vienna, 1892

35 Gustav Klimt (right) with (from left to right): Joseph Maria Olbrich, an unknown man and Koloman Moser in Fritz Waerndorfer's garden, Vienna c. 1898

1885 Klimt decorates the Hermes Villa in the Lainzer Tiergarten, a gift from Emperor Franz Joseph to his wife Elisabeth, after designs Hans Makart had produced before his death in 1884.

1886-1889 The "Artists Company" is commissioned to design the ceiling paintings for the two stairwells of the new Hofburg Theatre on Vienna's Ringstrasse. For their work the Emperor presents them with the Gold Cross of Merit. In 1888/89 Klimt travels to Innsbruck, Salzburg and the Königssee, to the cities of Krakow and Triest, then part of Austria, and to Munich.

1890 The "Artists Company" moves into a new studio at Josefstädter Strasse 21 in the 7th District. Klimt travels to Venice, Tyrol and Carinthia. For his painting *Auditorium of the Old Burgtheater* (1888) (19) he is awarded the prestigious Emperor's Prize.

1891 Klimt designs the frescoes in the stairwell of Vienna's Kunsthistorisches Museum. He is inducted into the Association of Viennese Visual Artists (now the Association of Austrian Artists). His brother Ernst marries Helene Flöge (1871–1936). Her sister Emilie Flöge (1874–1952) becomes Klimt's lover and lifelong muse.

1892 Klimt's father dies in July and his brother Ernst in December. Gustav assumes guardianship of his niece Helene, the daughter of Ernst and Helene Klimt, called "Lentschi" (1892–1980).

1894 Together with Matsch, Klimt is commissioned to decorate the auditorium of the University of Vienna with paintings. Klimt chooses to paint allegories of the three faculties of Philosophy, Medicine, and Jurisprudence, Matsch the one of Theology and the huge ceiling painting. Matsch's works are found satisfactory, but Klimt's cause a scandal, and are not accepted. Klimt will finally repay his artist's fee in 1907, and take back the pictures. Koloman Moser and the Lederer family buy back the designs. In 1945 all three of Klimt's paintings will be destroyed in a fire at Schloss Immendorf, where they had been placed for safe keeping.

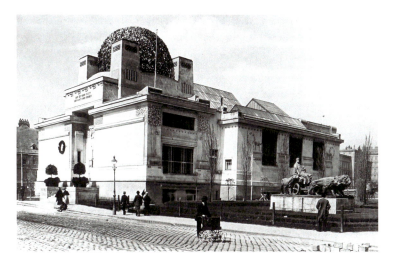

36 The Vienna Secession Building, c. 1910

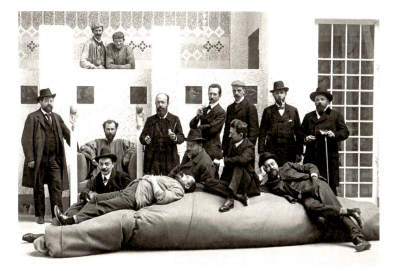

37 Members of the Vienna Secession on the occasion of the exhibition of Max Klinger's Beethoven Monument in the Secession Building, 1902. From back left to front right:
Anton Stark, Gustav Klimt, Koloman Moser, Adolf Böhm, Maximilian Lenz, Ernst Stöhr, Wilhelm List, Emil Orlik, Maximilian Kurzweil, Leopold Stolba, Carl Moll and Rudolf Bacher

1897 Klimt leaves the Association of Viennese Visual Artists. Instead, he becomes a founding member of the Vienna Secession, and until 1899 its first president. From now on he will regularly spend his summer vacation with Emilie Flöge in the area of Kammer on the Attersee in the Salzkammergut, where he paints his first landscapes. At the same time he begins a long-time relationship with Marie "Mizzi" Zimmermann (1879–1975); two illegitimate sons are born: Gustav (1899–1976) and Otto Zimmermann (born and died in 1902).

1898/99 The first Secession exhibition is held in the headquarters of the Horticultural Society. The group publishes the first issue of its journal *Ver Sacrum* ("Sacred Spring"). Klimt is also named a corresponding member of the Munich Secession. The second exhibition of the artists' group is held during the same year in the new Secession Building designed by Joseph Maria Olbrich (1867–1908). A portrait of Sonja Knips establishes Klimt's triumphal progress as the most sought-after portraitist of Viennese high-society women. In 1899 Gustav Ucicky (1899–1961) is born, Klimt's son from his relationship with Maria Ucicka (1880–1928).

1900 Klimt's painting *Philosophy*, which had been rejected by 87 University of Vienna professors, is awarded a gold medal at the Paris World's Fair.

1902 At the 14th exhibition of the Vienna Secession, which is dedicated to Ludwig van Beethoven, Klimt presents his *Beethoven Frieze*, 34 metres long and painted for the left-hand gallery of the Secession Building. He meets Auguste Rodin, who is staying in Vienna during a show of his sculptures, and is impressed by the sculptor's break with the smooth, stiff forms of academic sculpture and his representation of such emotions as sorrow and ecstasy.

1903 Klimt undertakes a study trip to Venice, Ravenna and Florence. His so-called "Golden Period" begins. Eighty of his works are shown at the Secession. The architect Josef Hoffmann (1870–1956), the painter Koloman Moser (1868–1918), and the industrialist Fritz Waerndorfer (1868–1939) establish the Wiener Werkstätte.

38 During Regatta Day on the sun terrace of the Villa Paulick boathouse in Seewalchen on the Attersee, 1904

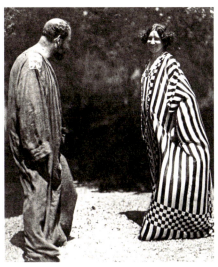

39 With Emilie Flöge in the garden in front of Klimt's atelier at Josefstädter Strasse 21 in Vienna, 1905

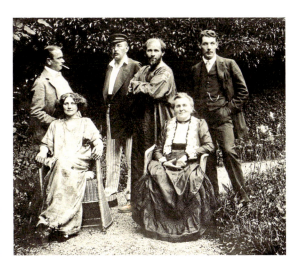

40 Gustav Klimt, Emilie Flöge and her mother Barbara with friends in the garden of the Oleander Villa in Kammer on the Attersee, 1908

1904 Klimt draws designs for the wall mosaics in the dining room of the Palais Stoclet in Brussels, which are realized by the Wiener Werkstätte. The Palais is considered the Werkstätte's most important *Gesamtkunstwerk*. Emilie Flöge opens the fashion salon "Flöge Sisters" at Mariahilfer Strasse 1b in Vienna, for which Klimt provides designs.

1905 Owing to differences of opinion between the "naturalist wing" and a group around Klimt, whose interest following the founding of the Wiener Werkstätte was combining the fine and applied arts into a *Gesamtkunstwerk*, Klimt and other artists resign from the Secession. His pictures are removed from the Secession Building. He paints his largest easel painting, *The Three Ages of Woman*.

1906 Klimt becomes president of the newly established League of Austrian Artists. He travels to Brussels, where he visits the Stoclets, and to London, Germany, and Italy.

1907 Klimt's university faculty pictures are shown in Berlin. He becomes acquainted with the young painter Egon Schiele (1890–1918); the two artists will later influence each other. He completes his first portrait of Adele Bloch-Bauer (1881–1925).

1908 With colleagues from the Wiener Werkstätte, Klimt organizes the Kunstschau on the occasion of the 60th anniversary of the coronation of Emperor Franz Joseph. An entire room is devoted to his paintings. Among them is *The Kiss (Lovers)*, today his most famous painting, which is purchased by the Ministry of Culture and Education. The Galleria d'Arte Moderna in Rome purchases his painting *The Three Ages of Woman*, and the Historisches Museum der Stadt Wien the portrait of Emilie Flöge, whose fashion salon is a success.

1909/10 Klimt undertakes journeys to France, Spain and Bohemia. In Paris he gets to know works by Henri de Toulouse-Lautrec, Vincent van Gogh, Paul Gauguin and Henri Matisse. He is represented in exhibitions in Munich, Berlin and Vienna, where there is a second Kunstschau, at which international artists are also represented. In 1910 important works of his are shown at the 9th Venice Biennale.

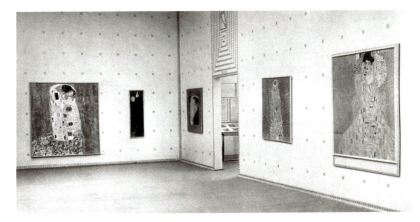

41 *Kunstschau Wien*, exhibition gallery with paintings by Gustav Klimt, 1908

42 Gustav Klimt in the garden in front of his atelier at Josefstädter Strasse 21 in Vienna, c. 1910

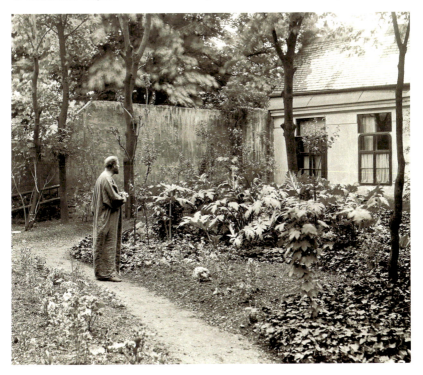

1911 Klimt participates in the international art exhibition in Rome, at which he is awarded First Prize for his painting *Death and Life*. In Brussels his mosaic frieze in the Palais Stoclet is finished. Additional travels take him to London and Madrid. He moves into his last studio at Feldmühlgasse 11 in Vienna's 13th District, and begins a long-term relationship with Consuela Camilla Huber (1896–1978), with whom he has three children: Gustav (1912–1989), Charlotte (1914–1915) and Wilhelm (1915–1943).

1912 Klimt works are shown at the *Great Art Exhibition* in Dresden. He paints his second portrait of Adele Bloch-Bauer.

1913 Klimt contributes works to exhibitions in Budapest, Munich and Mannheim.

1915-1917 Klimt's mother dies in February. He spends the summer on the Attersee for the last time. Together with Egon Schiele and Oskar Kokoschka, Klimt participates in 1916 in the exhibition at the Berlin Secession. In the following year he is named an honorary member of the Vienna and Munich academies of art.

1918 Klimt dies at age 55 in the Allgemeines Krankenhaus following a stroke on 6 February, and is buried in Hietzing Cemetery in Vienna.

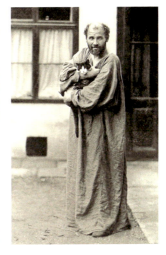

43 The dining room of the Palais Stoclet with the *Stoclet Frieze*, c. 1911

44 Gustav Klimt holding one of his cats, in front of his atelier at Josefstädter Strasse 21 in Vienna, c. 1912

45 Klimt's atelier at Feldmühlgasse 11 in Vienna, Ober-St. Veit, 1918

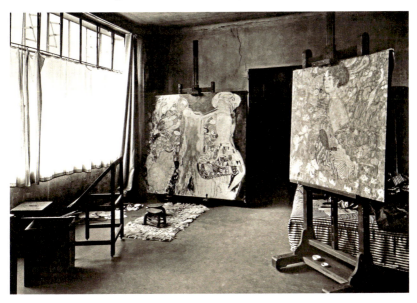

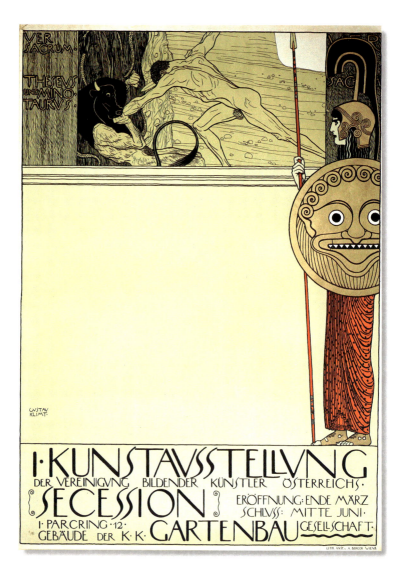

Poster for the first Secession exhibition (before censorship), 1898
Lithograph, 62 × 43 cm, Wien Museum

ARCHIVE

Findings, Documents
1898–1910

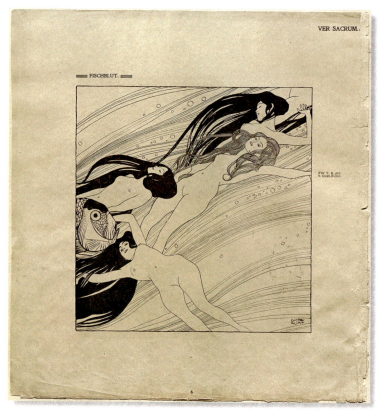

1 a

1

During his term as president of the Secession, founded in 1897, Klimt also devoted himself to illustration art and book decorations. For the issue of the journal Ver Sacrum *dedicated to him (March 1898) he designed vignettes, initials and illustrations. The ink drawing* Fish Blood *is Klimt's earliest autonomous depiction of an erotically charged underwater motif, typical of the "spirit art" of the Secession's founding period.*

1 a *Fish Blood*, in *Ver Sacrum* no. 3 (March 1898), page 6
Pen and ink, black crayon, 18.5 × 18.5 cm, Belvedere, Vienna

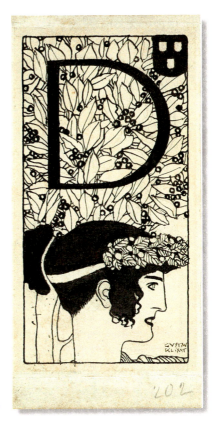

1b

In the early phase of the Secession, the god Apollo assumed a special, programmatic function as "Father of the Muses." In Greek mythology it is said that out of fear for the loss of her virginity the nymph Daphne, when pursued by Apollo, had herself transformed into a laurel tree, with which the god was subsequently inseparably associated. Apollo's symbolic presence is also seen in the form of the golden laurel cupola atop the Secession Building, opened in 1898 (36).

1b *Initial D*, in *Ver Sacrum* no. 3 (March 1898), page 23
Pen and brush and ink, 19.5 × 9.8 cm

2

2

In the drawing for the painting Philosophy *(6), the artist had already mani-
fested an altogether innovative approach to the naked human body. In the
nude studies for the painting* Medicine *(8), painted in 1901 as a counterpart to*
Philosophy, *Klimt found an even more radically modern approach to the nude
body.*

2 Transfer sketch for *Medicine*, c. 1900, black crayon, pencil
enlargement grid, 86 × 62 cm, Albertina, Vienna

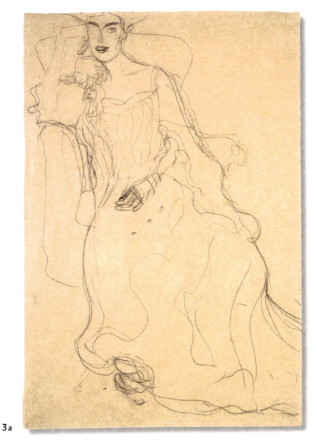

3a

3

A study of Klimt's drawings, comprising roughly 4,000 works, is essential for an understanding of his paintings. It also provides informative glimpses into the way he thought and worked, for there is virtually no written or verbal testimony to his artistic intentions.

3a *Adele Bloch-Bauer, Seated in an Armchair, From the Front*, 1903
45.3 × 31.7 cm, Neue Galerie, New York

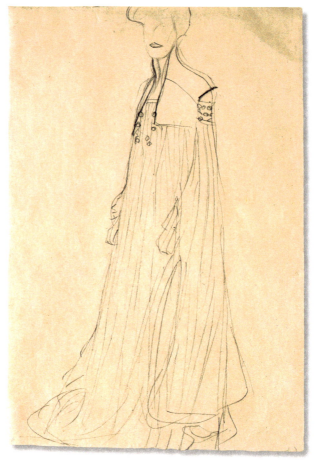

3b

<hr />

3b *Adele Bloch-Bauer, Standing in Three-Quarter Profile Facing Left,* 1903
Charcoal, 45.3 × 31.7 cm, Neue Galerie, New York

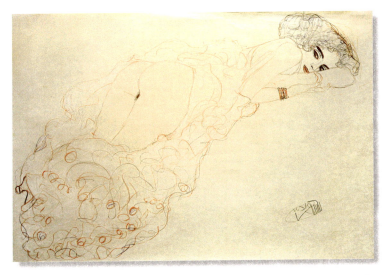

There are numerous studies that Klimt made in preparation for his paintings, especially for the female portraits. For the painting Adele Bloch-Bauer I *(1), completed in 1907, he made an unusually large number of drawings of the extravagant young woman, the daughter of the banker Moritz Bauer and wife of the industrial magnate Ferdinand Bloch. In them Adele is posed both seated and standing. These works combine soft, flowing lines with the geometrically-based flatness typical of Klimt's "Golden Period."*

Around 1910, Klimt the draughtsman devoted himself increasingly to the theme of Eros, one that he explored up until his death in a free, highly sophisticated linear idiom. His erotic studies, for which he was accused of pornography during his lifetime, were models for the young Egon Schiele's taboo-breaking portraits.

3c *Nude Lying on Her Stomach Looking to the Right*, 1910, pencil, blue and red coloured crayons, highlights in white, 37 × 56 cm, private collection

SOURCES

LITERATURE USED

Andreas Gabelmann: *Gustav Klimt und das
ewig Weibliche*, Ostfildern 2011
Mona Horncastle, Alfred Weidinger:
Gustav Klimt. Die Biografie, Vienna 2018
Rainer Metzger (ed.): *Vienna 1900*, Cologne 2020
Tobias G. Natter: *Klimt and the Women of
Vienna's Golden Age: 1900–1908*, exh. cat.
New York, Neue Galerie, New York 2016
Gilles Néret: *Klimt. 1862–1918. Die Welt in
weiblicher Form*, Cologne 2021
Christian Philipsen: *Gustav Klimt & Hugo
Henneberg. Zwei Künstler der Wiener Secession*,
exh. cat. Halle (Saale), Stiftung Moritzburg,
Cologne 2018
Harald Salfellner: *Klimt. An Illustrated Life*,
Prague 2019
Elisabeth Sandmann: *Der gestohlene Klimt.
Wie sich Maria Altmann die Goldene Adele
zurückholte*, Munich 2018
Christoph Thun-Hohenstein, Beate Murr (eds.):
*Gustav Klimt. Expectation and Fulfillment.
Cartoons for the Mosaic Frieze at Stoclet House*,
exh. cat. Vienna, MAK – Museum of Applied
Arts, Ostfildern 2012
Sandra Tretter, Peter Weinhäupl (eds.):
Gustav Klimt. Florale Welten, Vienna 2019

Published by
Hirmer Verlag GmbH
Bayerstraße 57–59
80335 Munich
Germany

Cover: *The Kiss (The Lovers)* (detail), 1928,
see p. 26/27
Double page 2/3: *Fulfilment* (detail), 1905/09,
see p. 31
Double page 4/5: *Schloss Kammer on the
Attersee III* (detail), 1924, see p. 51

www.hirmerpublishers.com

—
TRANSLATION
Russell Stockman, Vermont

—
COPY-EDITING
Jane Michael, Munich

—
PROJECT MANAGEMENT
Tanja Bokelmann, Munich

—
GRAPHIC DESIGN AND PRODUCTION
Marion Blomeyer, Rainald Schwarz, Munich

—
PRE-PRESS AND REPRO
Reproline mediateam GmbH, Munich

—
PRINTING AND BINDING
Grafisches Centrum Cuno, Calbe

Bibliographic information published by the
Deutsche Nationalbiliothek. The Deutsche
Nationalbibliothek lists this publication in the
Deutsche Nationalbibliografie; detailed
bibliographic data is available on the Internet
at http://dnb.d-nb.de.

ISBN 978-3-7774-3979-2

Printed in Germany

THE GREAT MASTERS OF ART SERIES

ALREADY PUBLISHED

WILLEM DE KOONING
978-3-7774-3073-7

LYONEL FEININGER
978-3-7774-2974-8

CONRAD FELIXMÜLLER
978-3-7774-3824-5

PAUL GAUGUIN
978-3-7774-2854-3

RICHARD GERSTL
978-3-7774-2622-8

JOHANNES ITTEN
978-3-7774-3172-7

VASILY KANDINSKY
978-3-7774-2759-1

ERNST LUDWIG KIRCHNER
978-3-7774-2958-8

GUSTAV KLIMT
978-3-7774-3979-2

HENRI MATISSE
978-3-7774-2848-2

PAULA MODERSOHN-BECKER
978-3-7774-3489-6

LÁSZLÓ MOHOLY-NAGY
978-3-7774-3403-2

KOLOMAN MOSER
978-3-7774-3072-0

ALFONS MUCHA
978-3-7774-3488-9

EMIL NOLDE
978-3-7774-2774-4

PABLO PICASSO
978-3-7774-2757-7

HANS PURRMANN
978-3-7774-3679-1

EGON SCHIELE
978-3-7774-2852-9

FLORINE STETTHEIMER
978-3-7774-3632-6

VINCENT VAN GOGH
978-3-7774-2758-4

MARIANNE VON WEREFKIN
978-3-7774-3306-6

www.hirmerpublishers.com